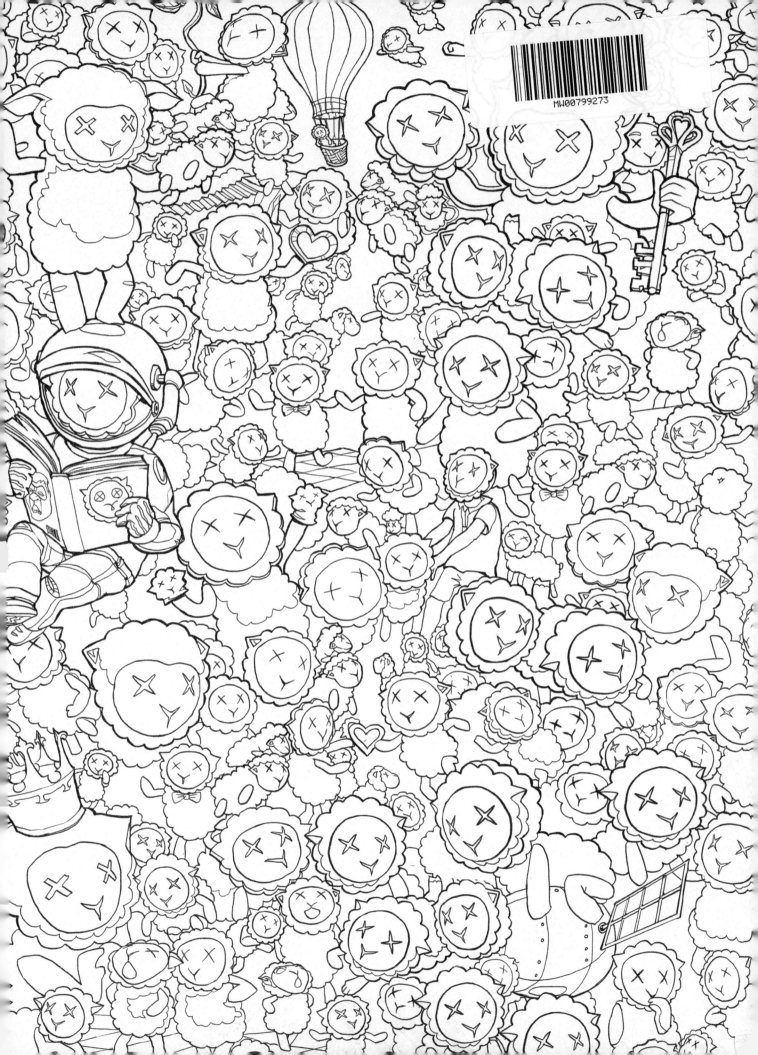
MW00799273

Share your art with Sheepy!
@MrSuicideSheep
#FeelingSheepish

MRSUICIDESHEEP'S CONCEPT ART COLOURING BOOK

COPYRIGHT © 2017 BY SEEKING BLUE RECORDS INC.

THIS IS AN OFFICIAL BOOK FROM SEEKING BLUE RECORDS INC.

ALL RIGHTS RESERVED.

UNLESS EXPRESSLY SHARING ON PERSONAL SOCIAL MEDIA, OR PERSONAL PLATFORMS FOR PERSONAL USE: NO PART OF THIS BOOK MAY BE REPRODUCED IN WHOLE OR PART, SCANNED, PHOTOCOPIED, RECORDED, DISTRIBUTED IN ANY PRINTED OR ELECTRONIC FORM, OR REPRODUCED IN ANY MANNER WHATSOEVER, OR BY ANY INFORMATION STORAGE AND RETRIEVAL SYSTEM NOW KNOWN OR HEREAFTER INVENTED, WITHOUT EXPRESS WRITTEN PERMISSION OF SEEKING BLUE RECORDS INC.

THE SCANNING, UPLOADING, AND DISTRIBUTION OF THIS BOOK VIA THE INTERNET OR VIA ANY OTHER MEANS WITHOUT PERMISSION OF SEEKING BLUE RECORDS INC. IS ILLEGAL AND PUNISHABLE BY LAW.

13 DIGIT ISBN: 978-1-7750717-0-9
13 DIGIT ISBN: 978-1-7750717-1-6 (HARDCOVER)

BOOK ILLUSTRATION BY DAVID NOREN
COVER COLOUR BY CARING WONG

CREATED BY SHEEPY!

Welcome to the first MrSuicideSheep Colouring Book!

This colouring book is dedicated to the MrSuicideSheep community.

It's been an incredible journey over the years. Together we've discovered new music and art from so many amazing producers and creators, from all over the world. I hope you'll enjoy this colouring book as much as I did putting it together with David and Caring!

Really looking forward to seeing how you will make it your own :)

Much love,
Sheepy
x . x

SHEEPY
QUEST!

Find each of these quest items throughout the book.

Once found, colour the item in!

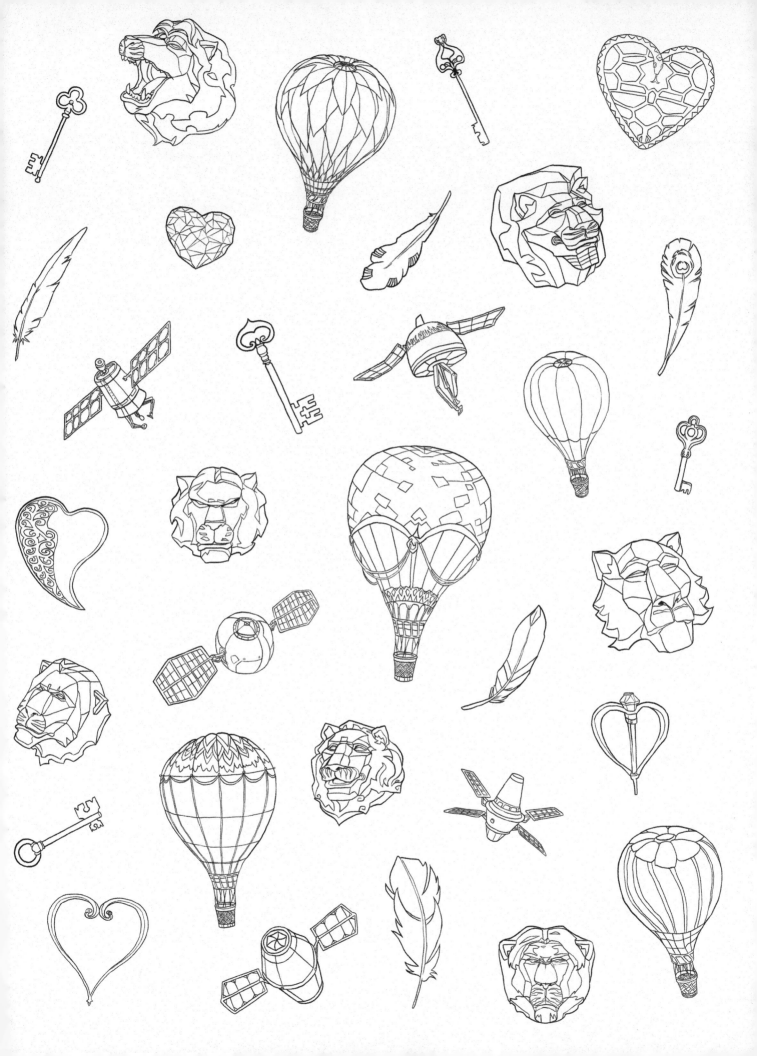

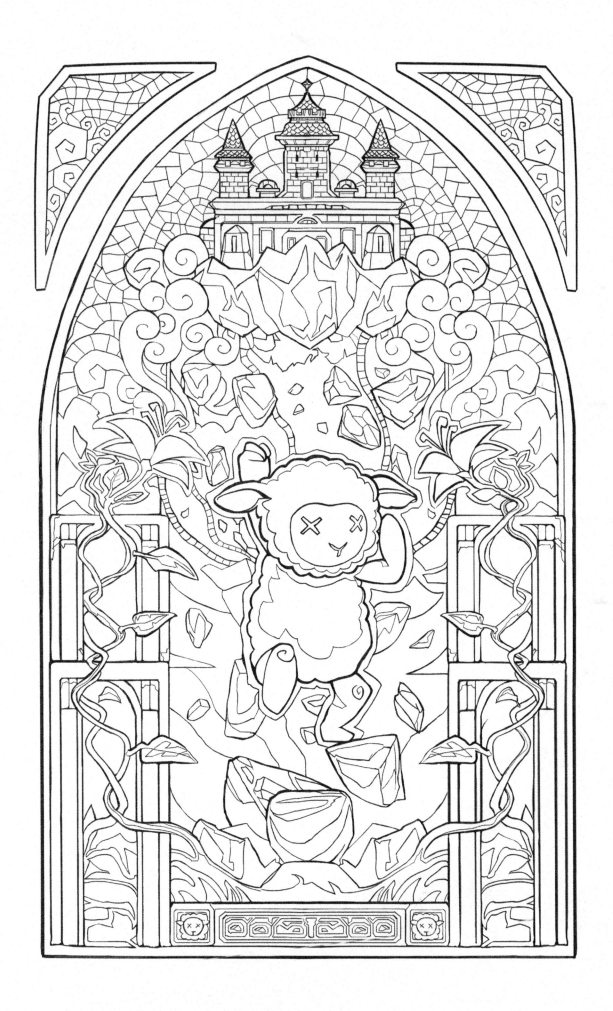

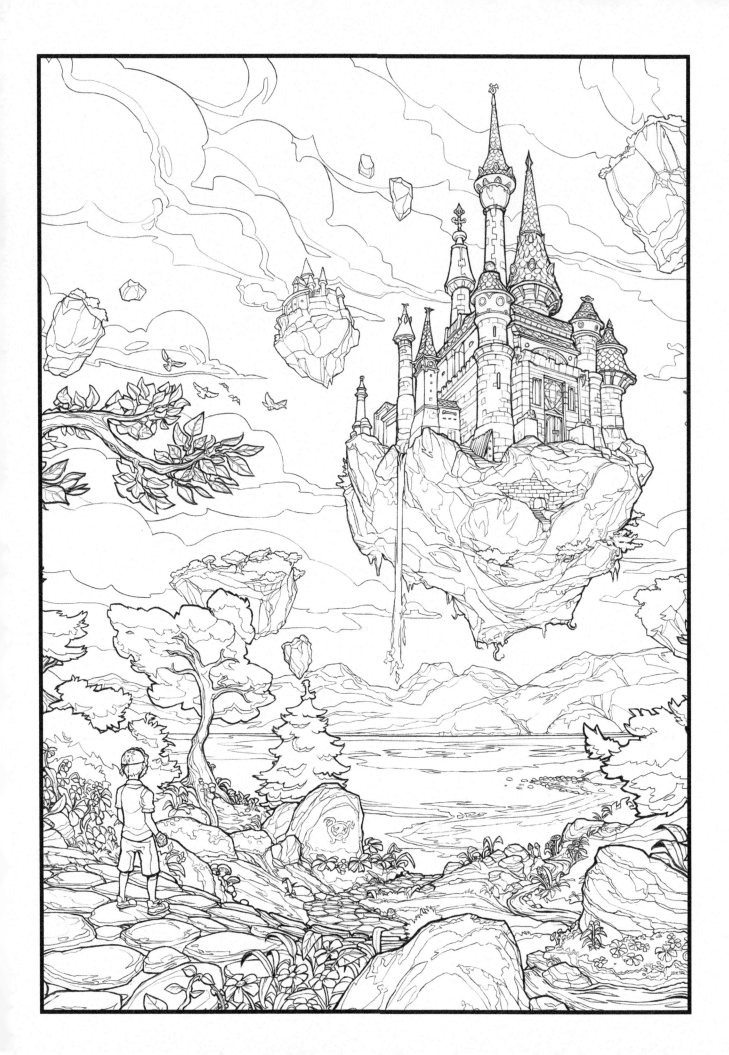

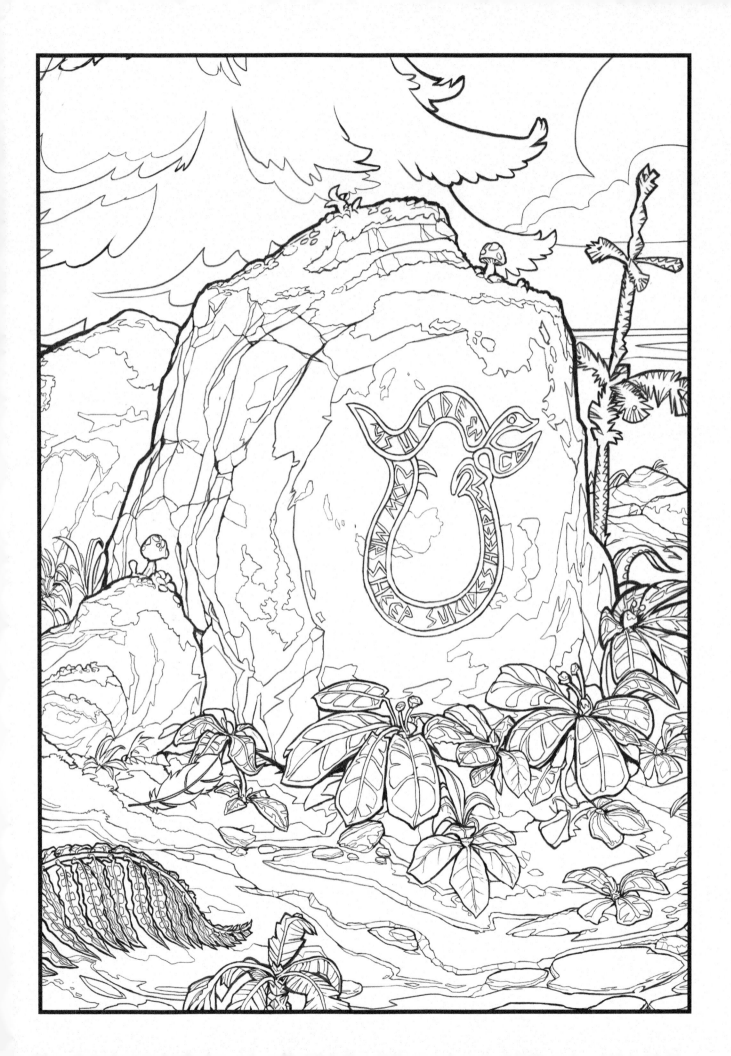

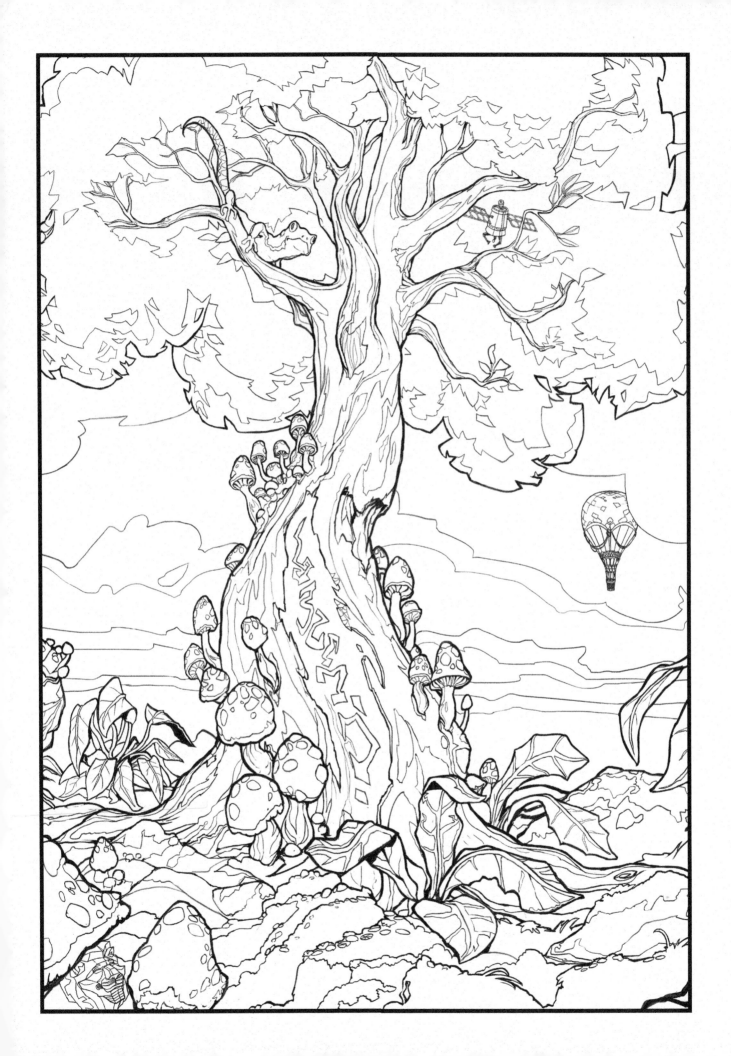

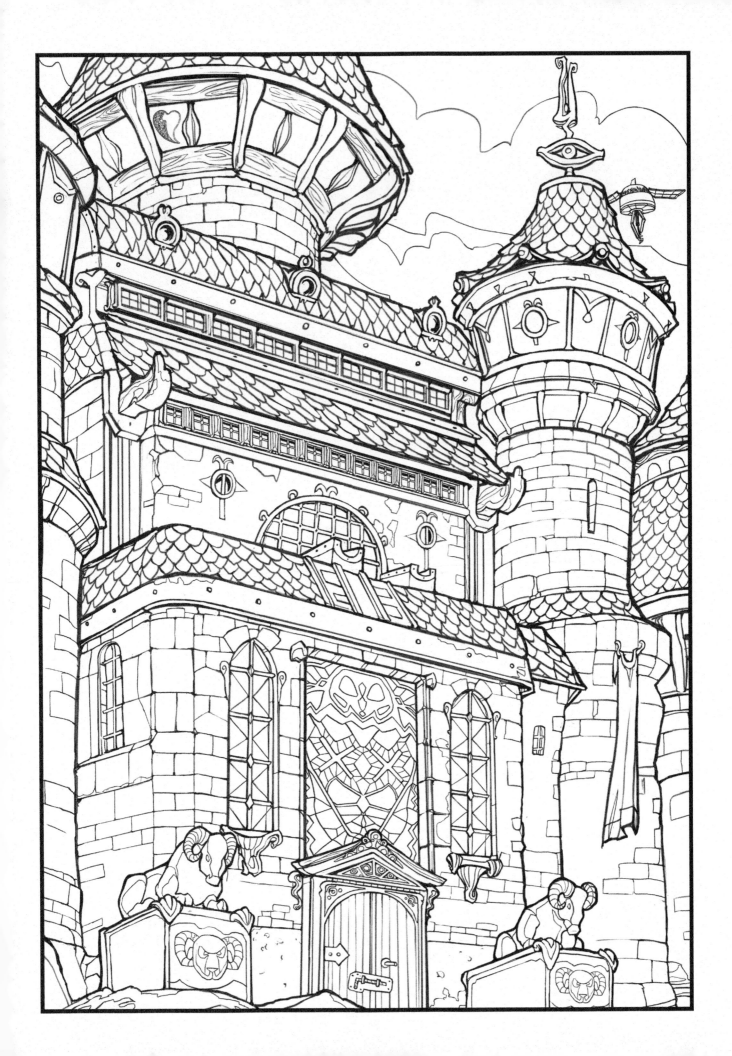

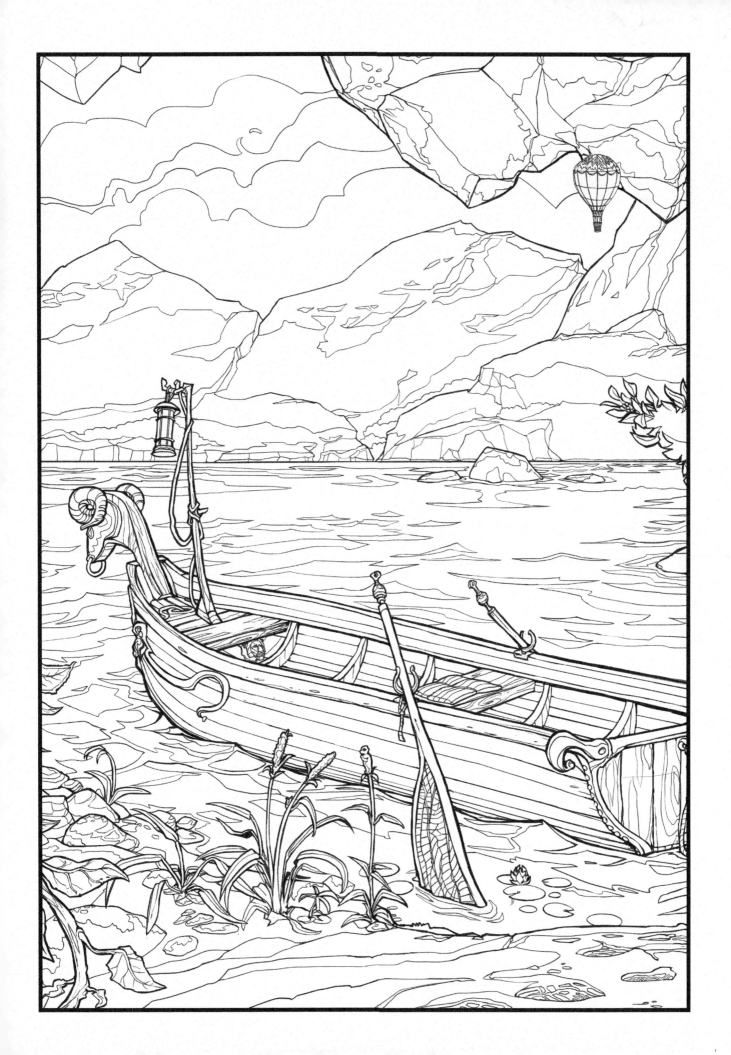

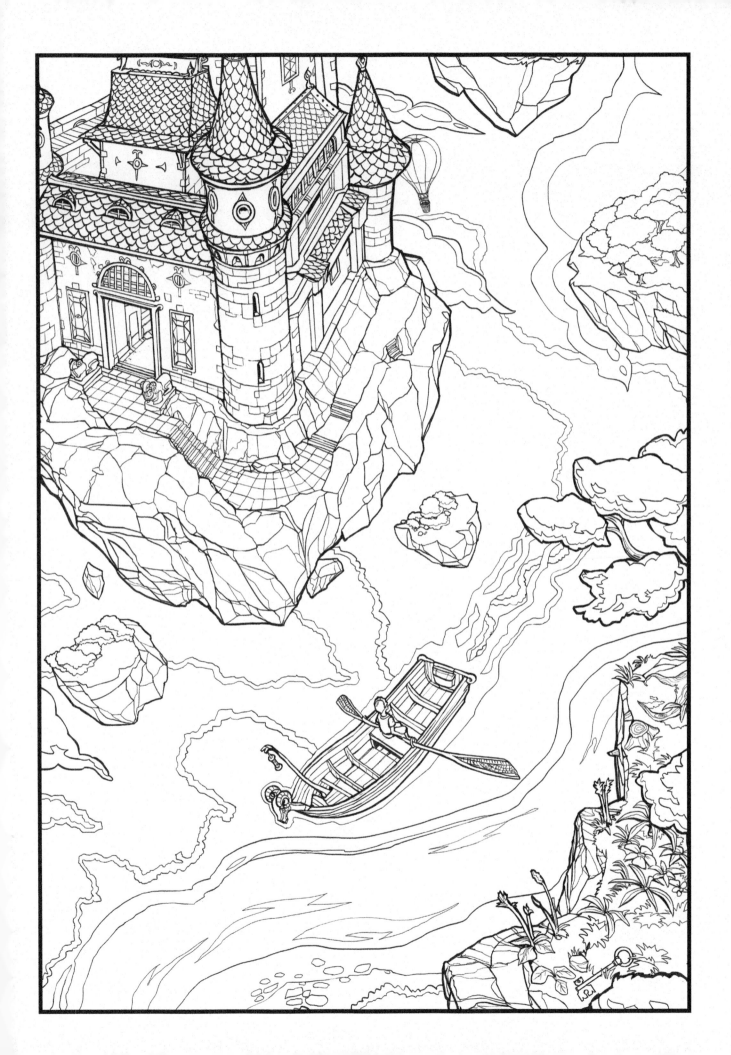

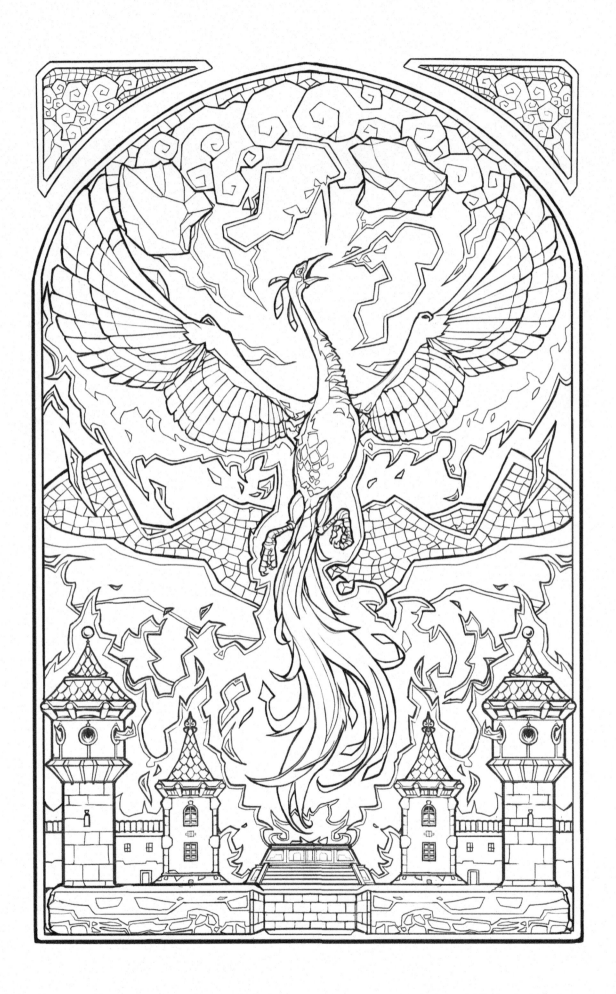

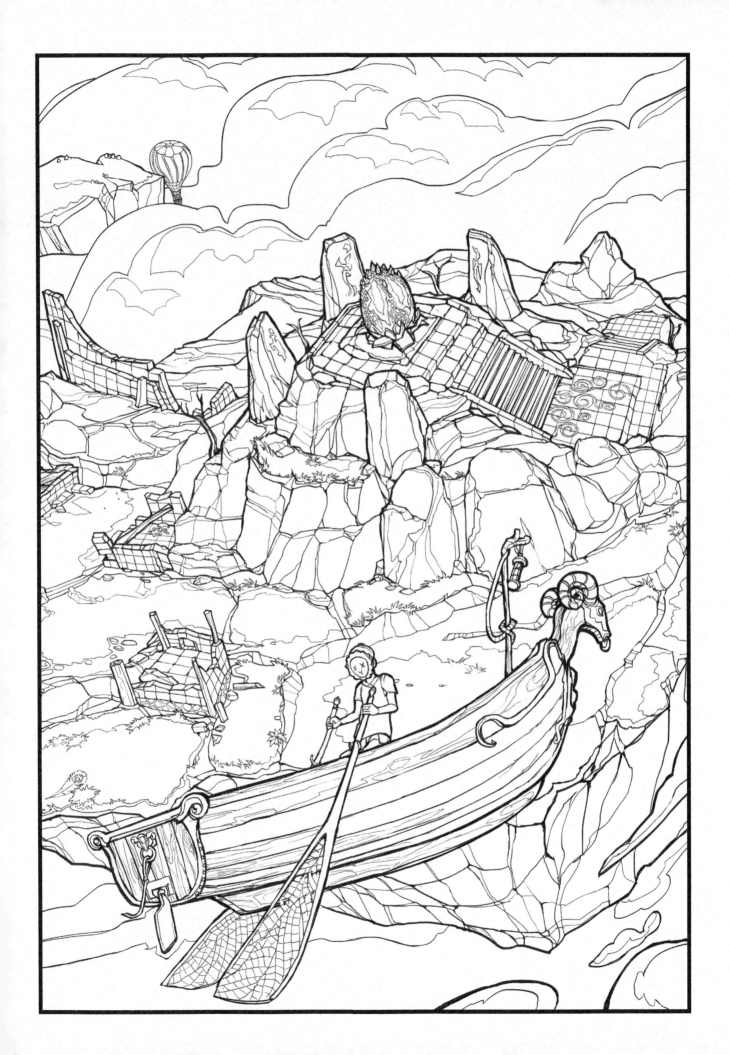

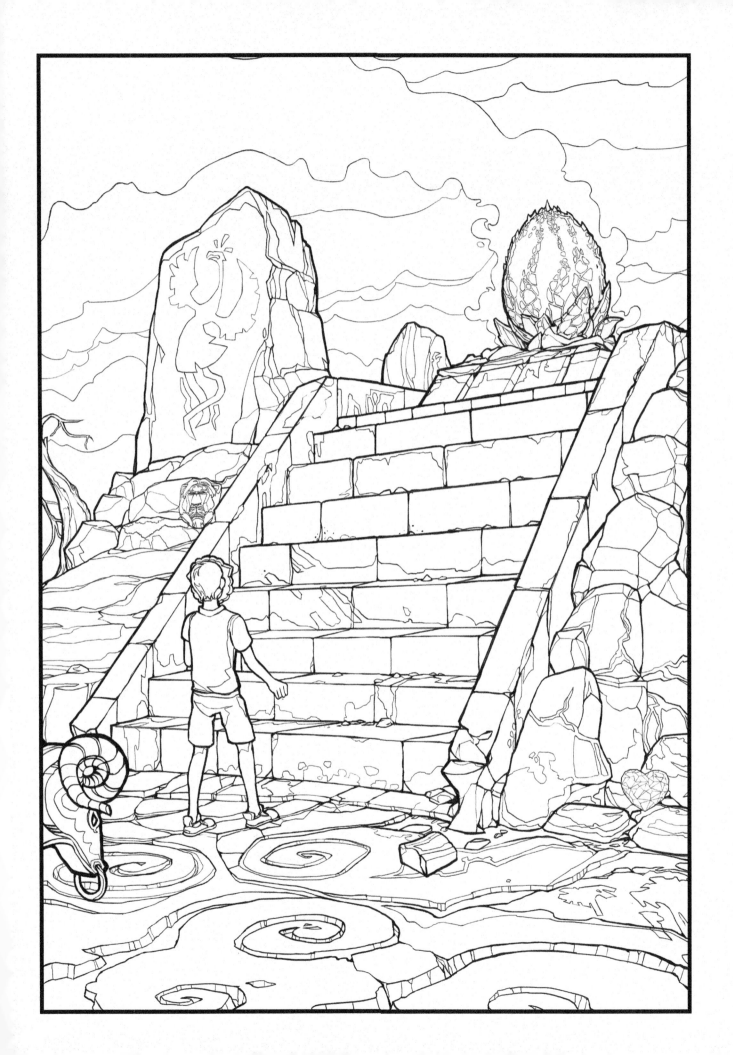

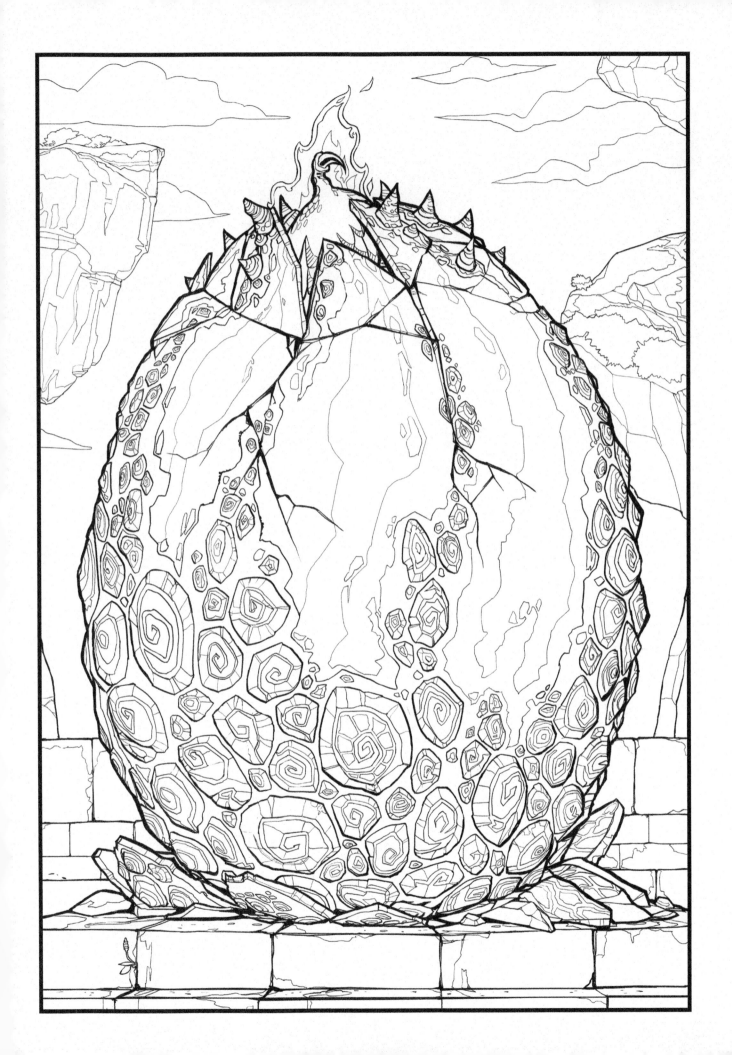

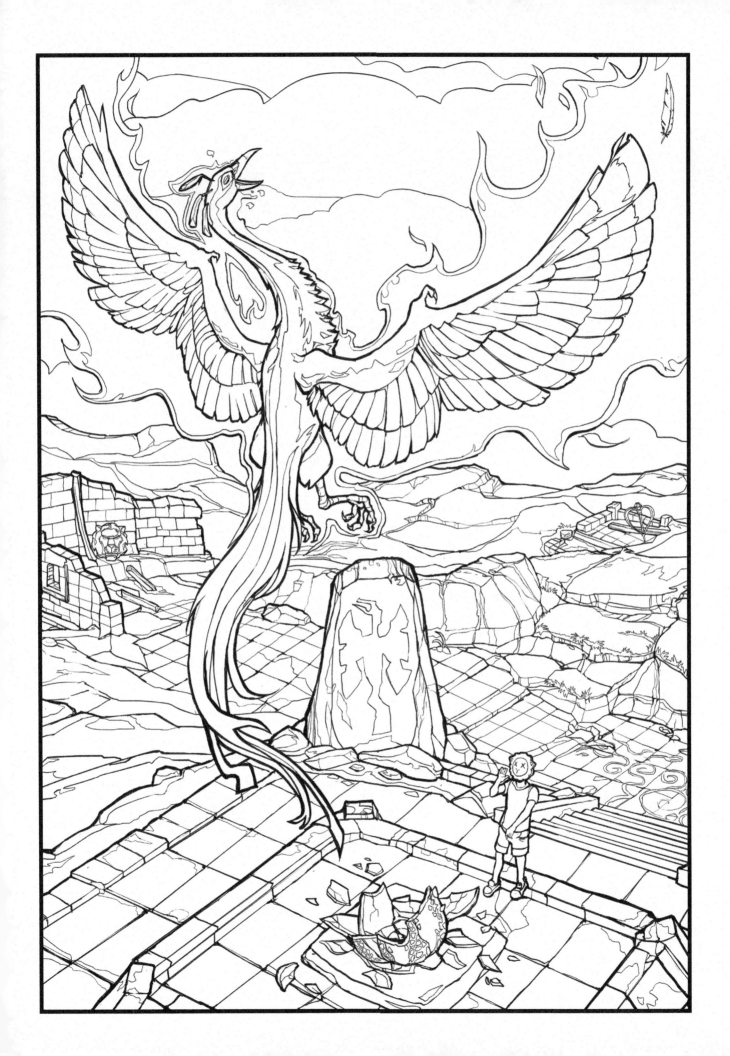

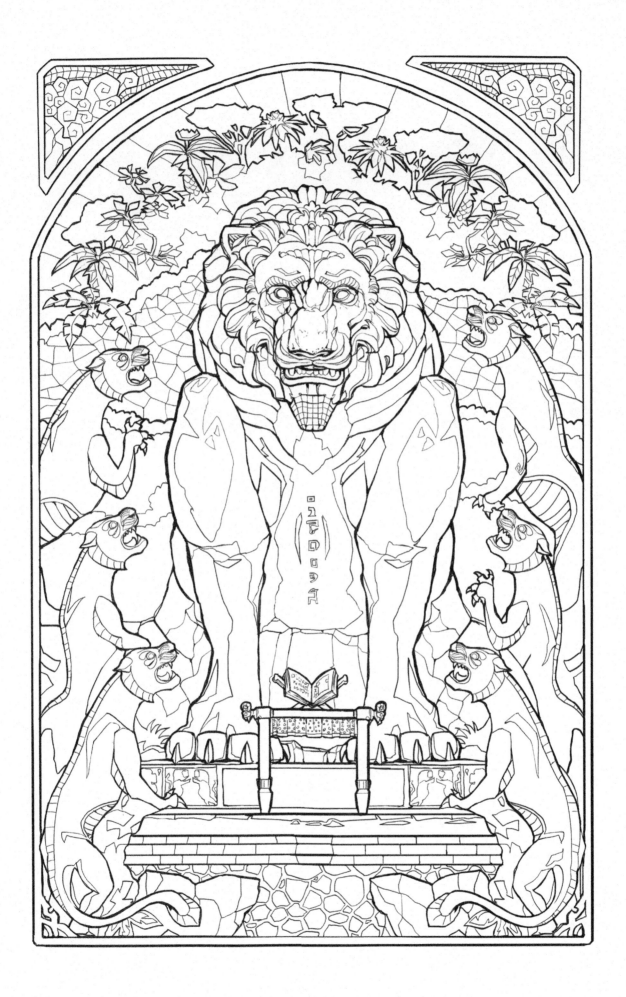

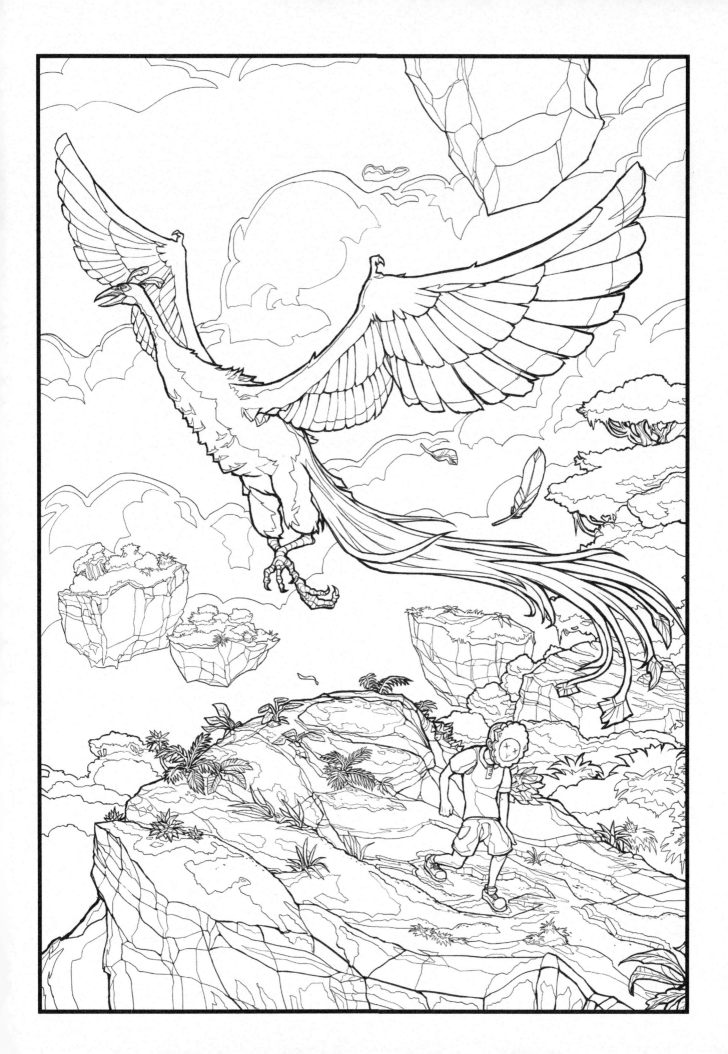

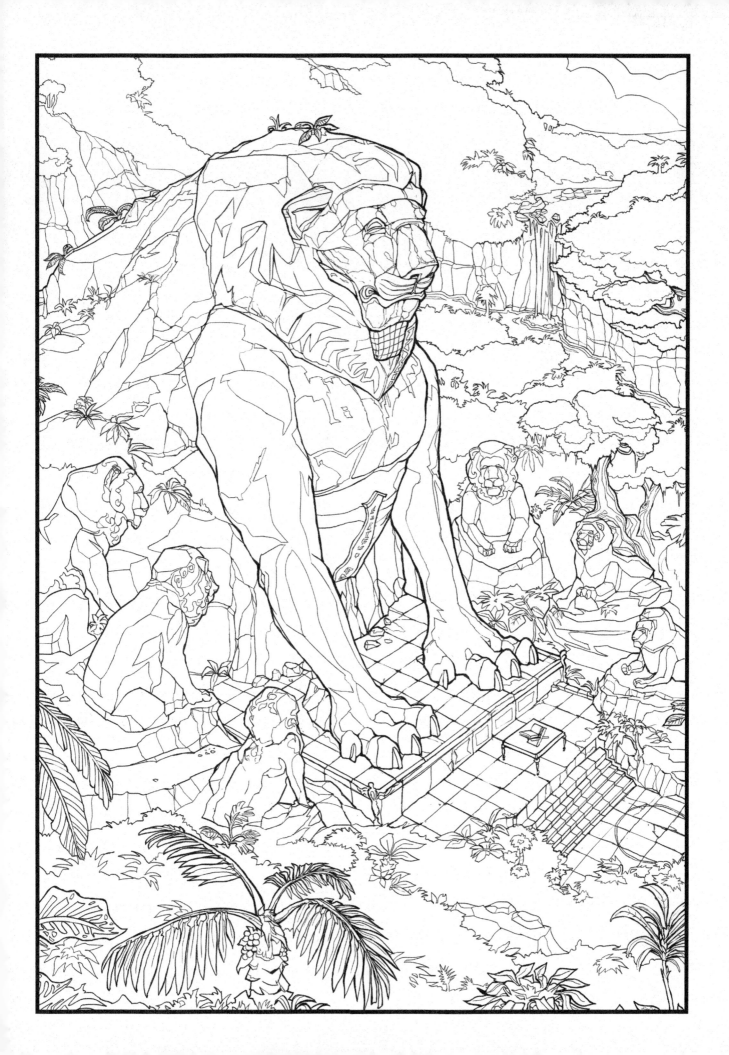

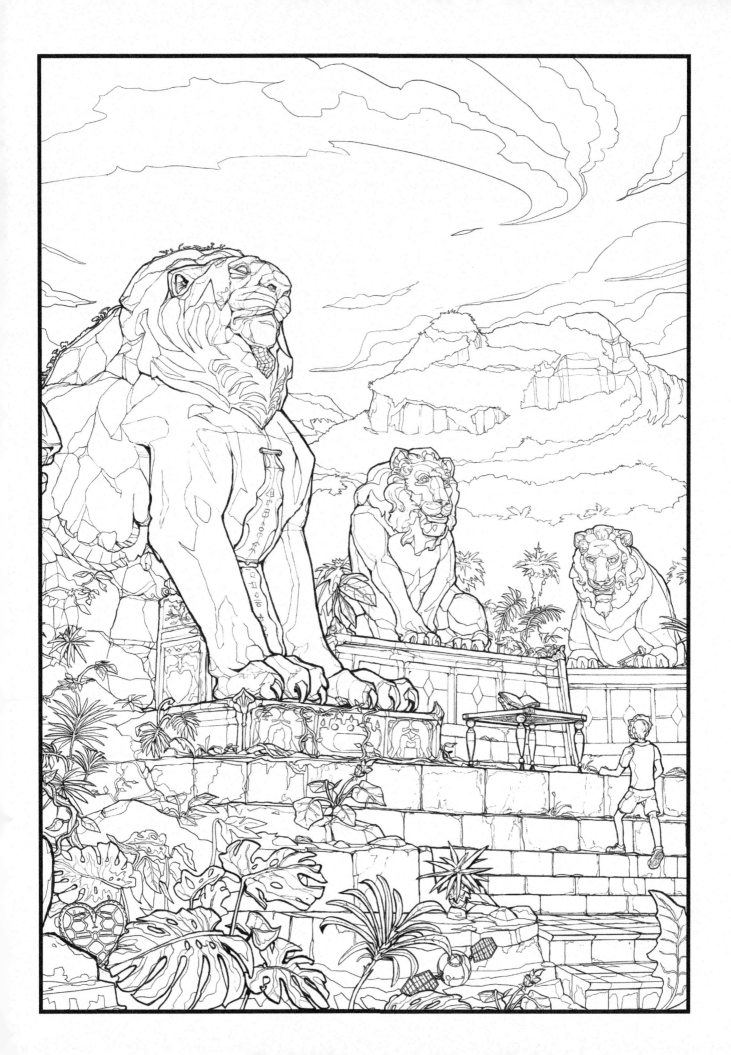

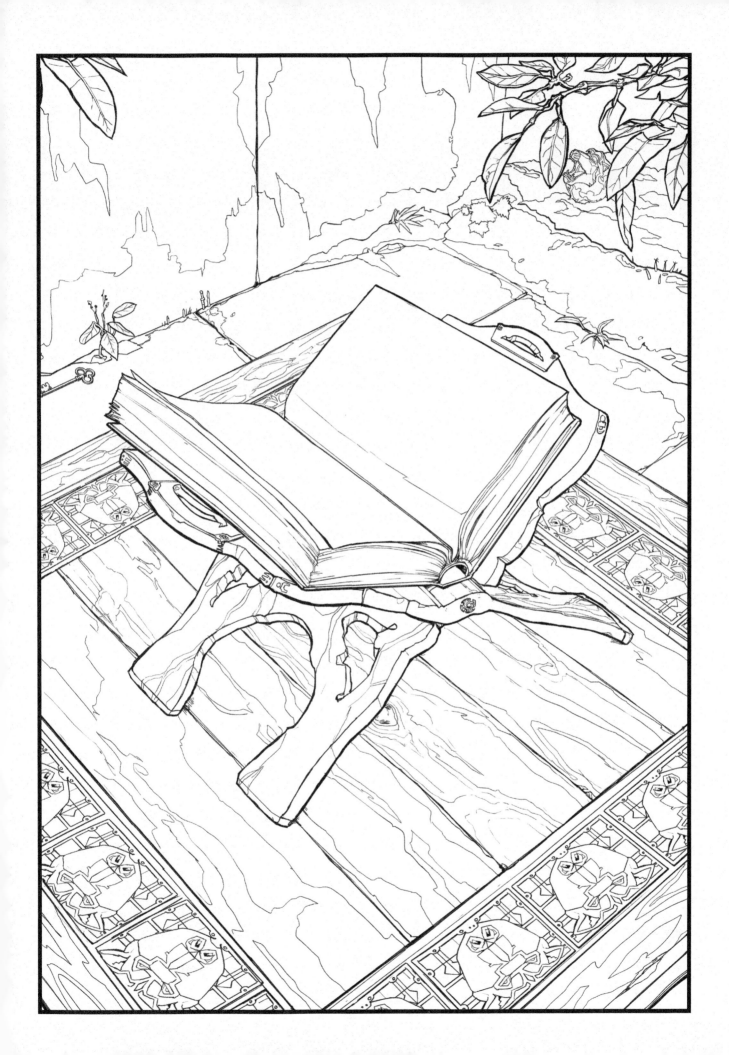

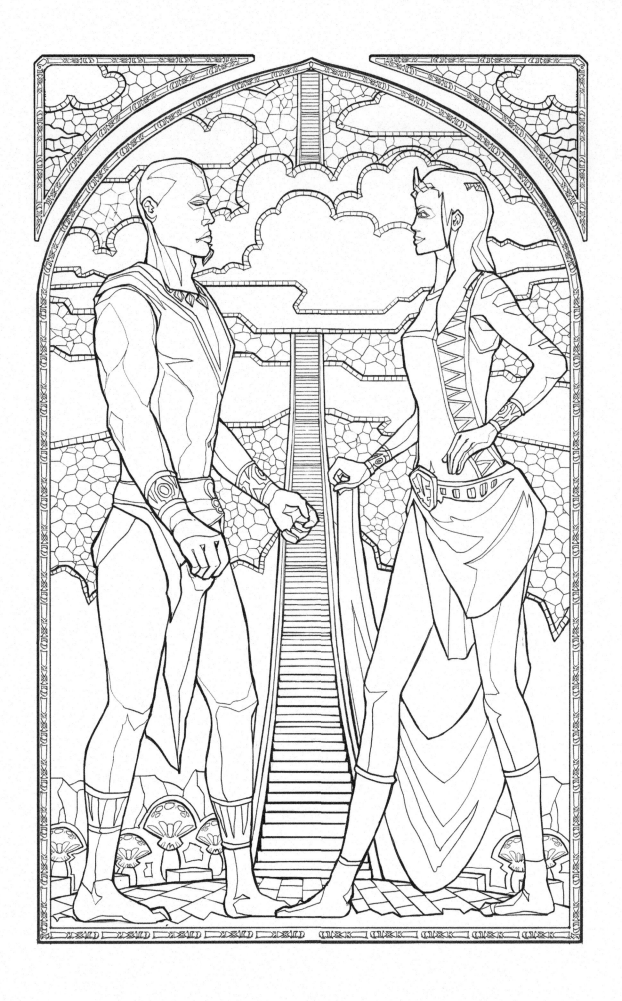

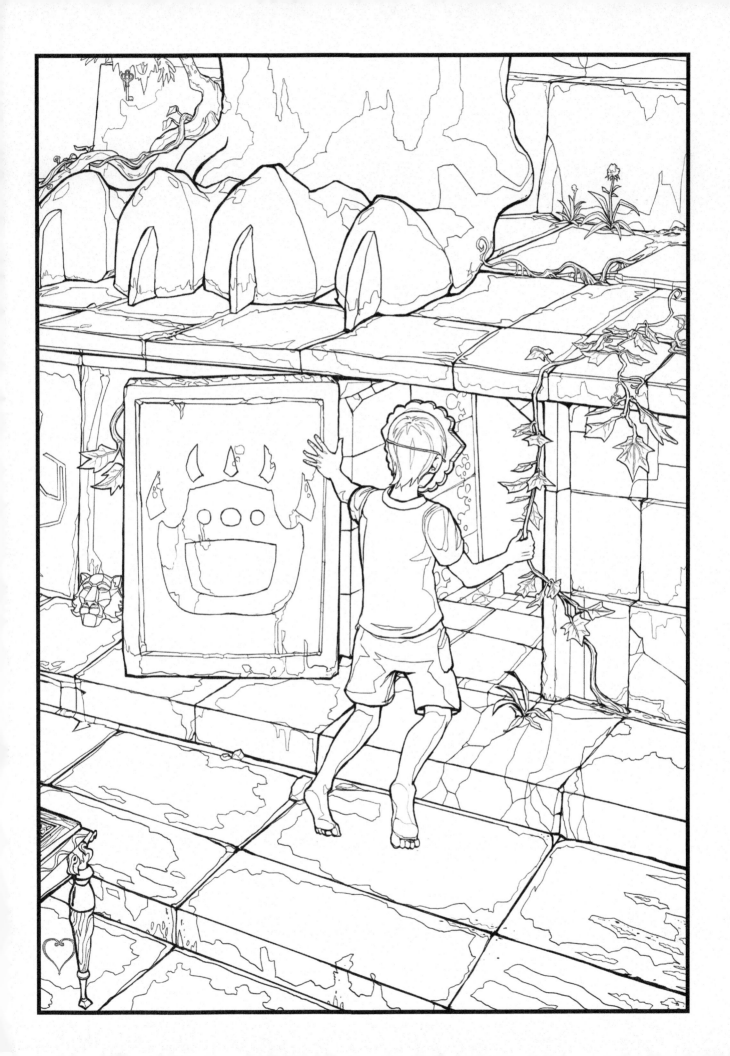

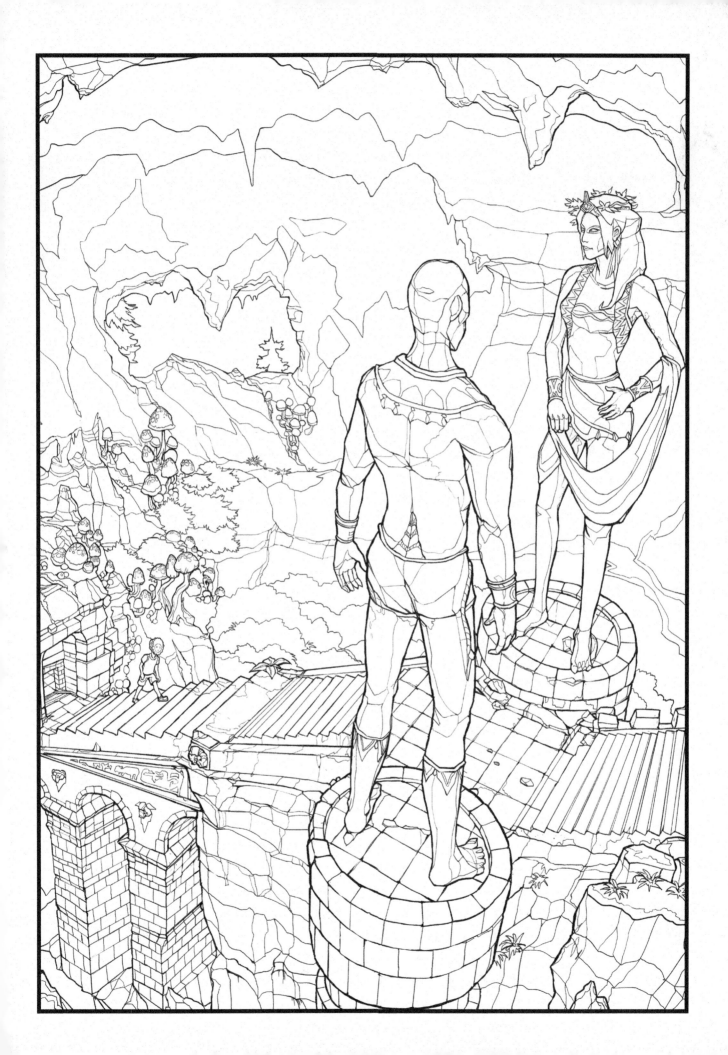

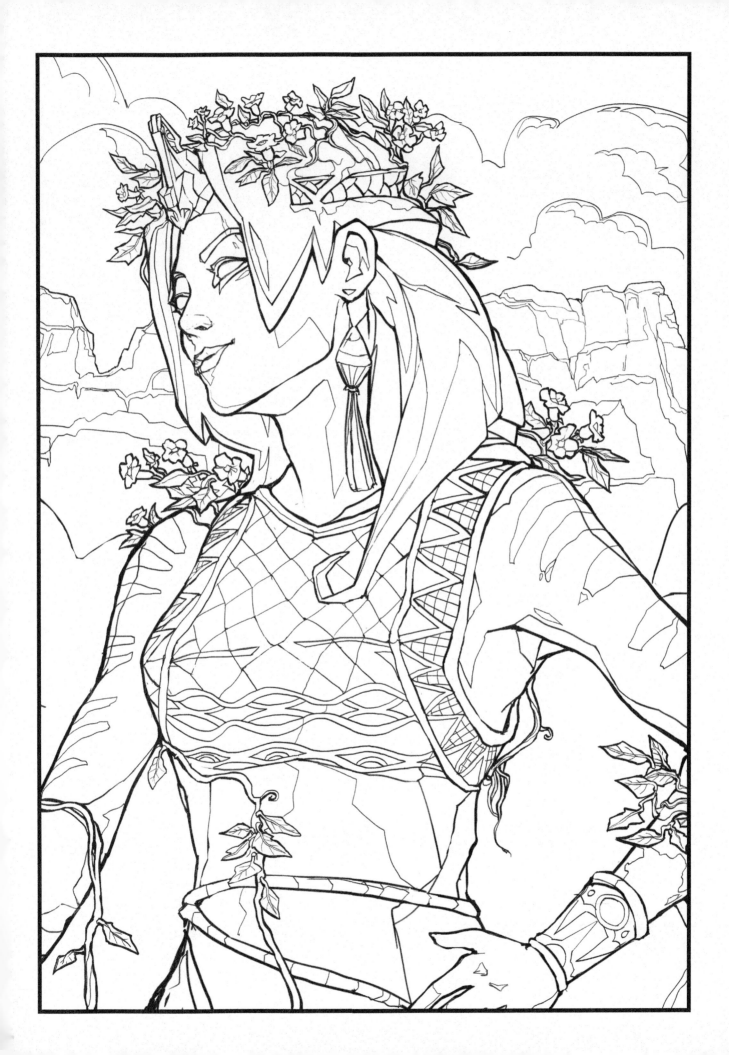

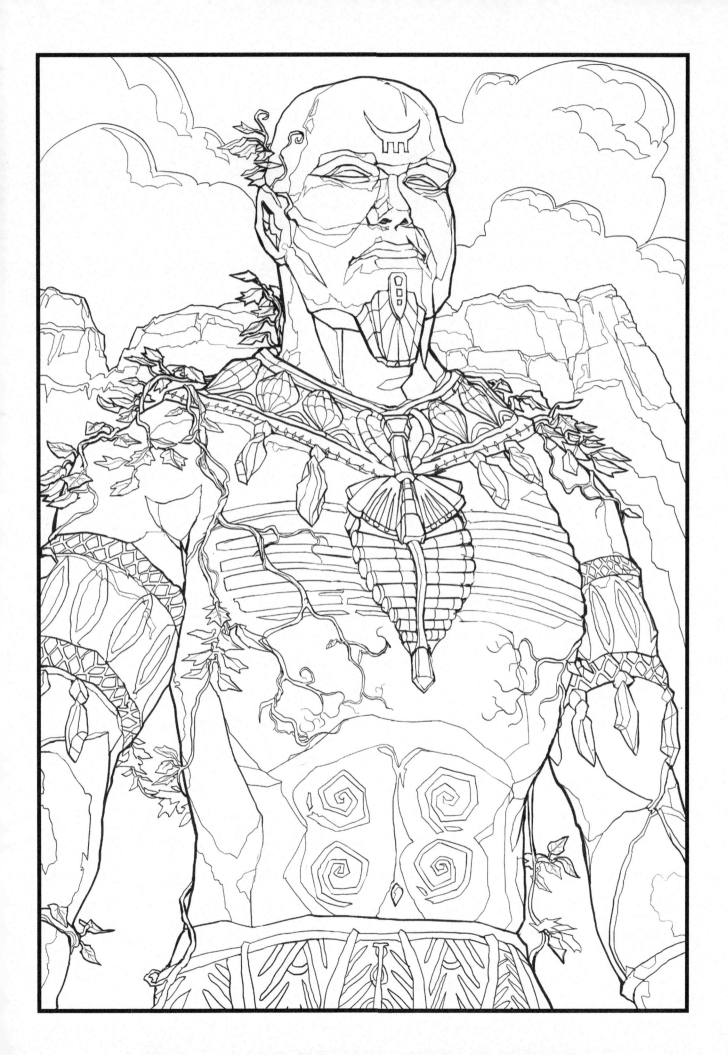

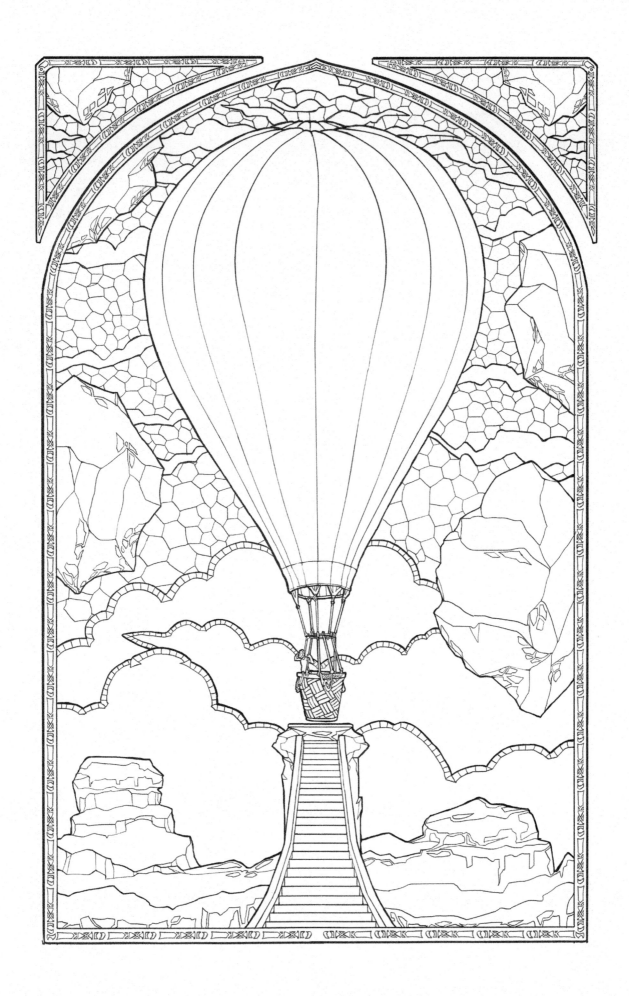

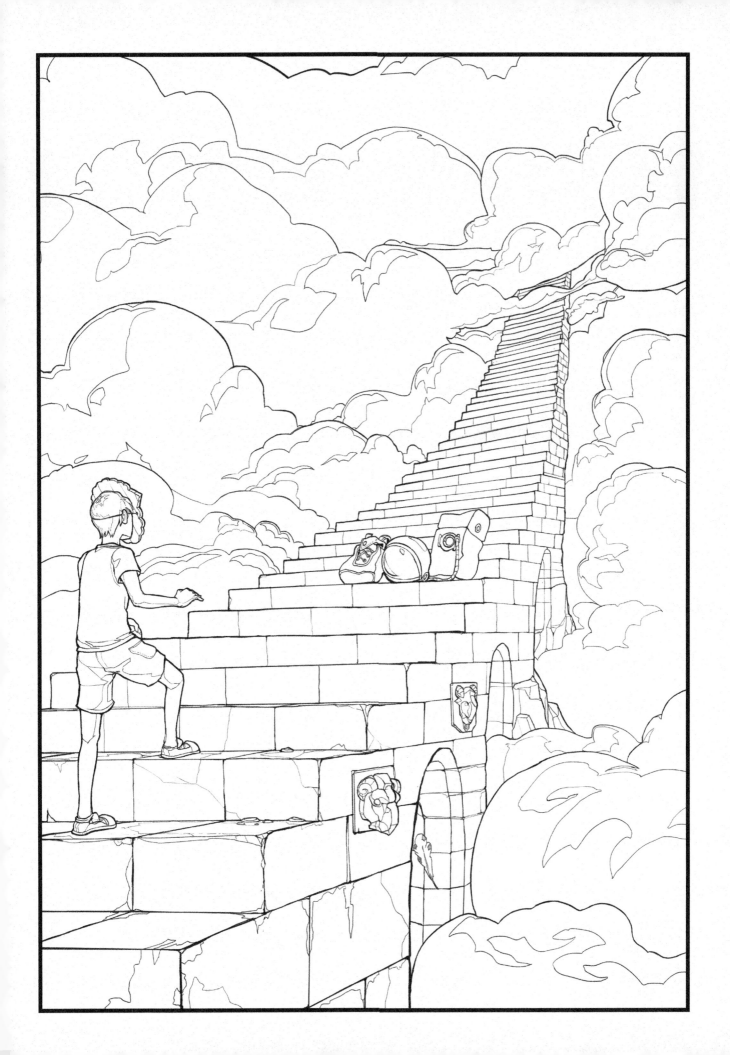

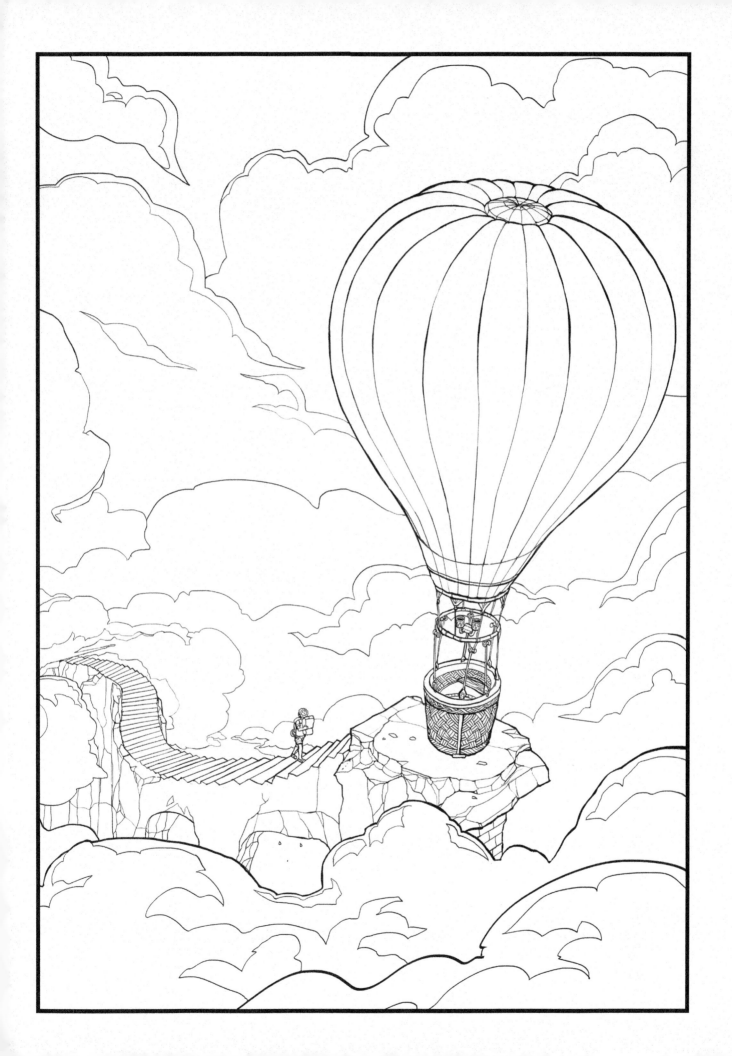

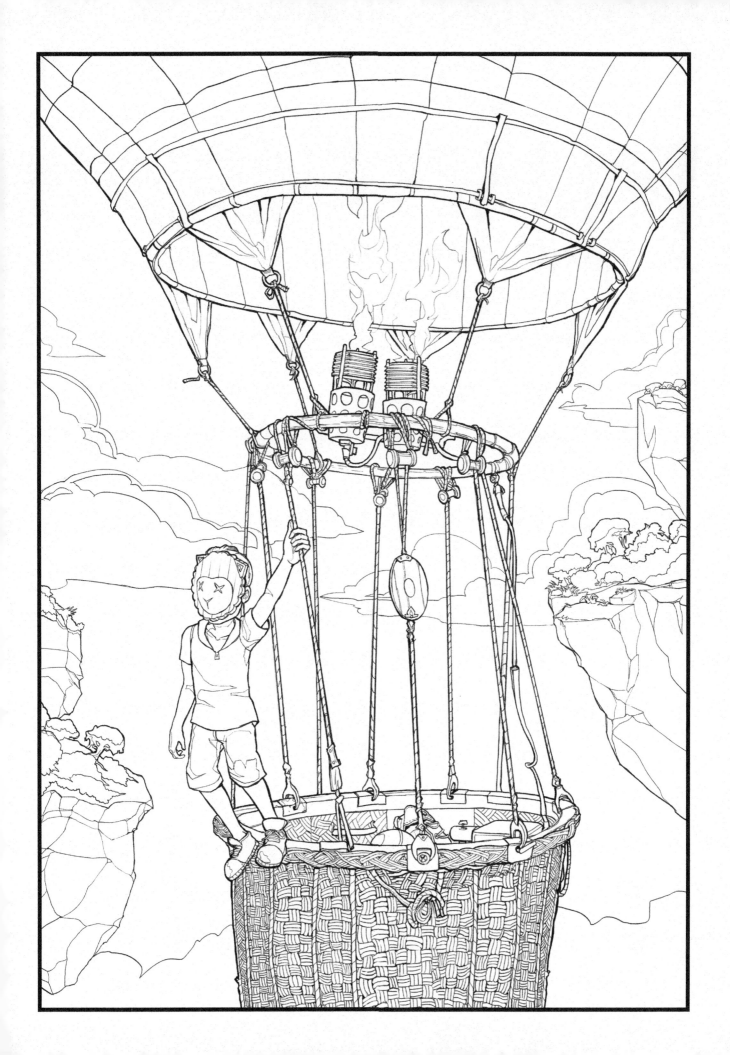

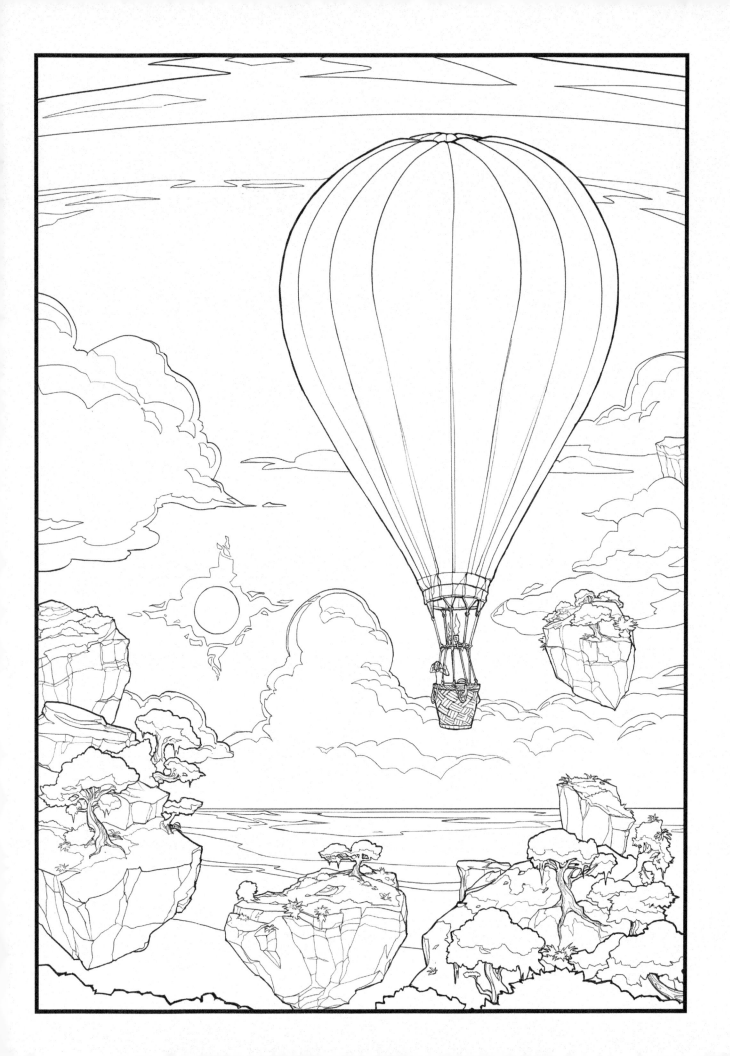

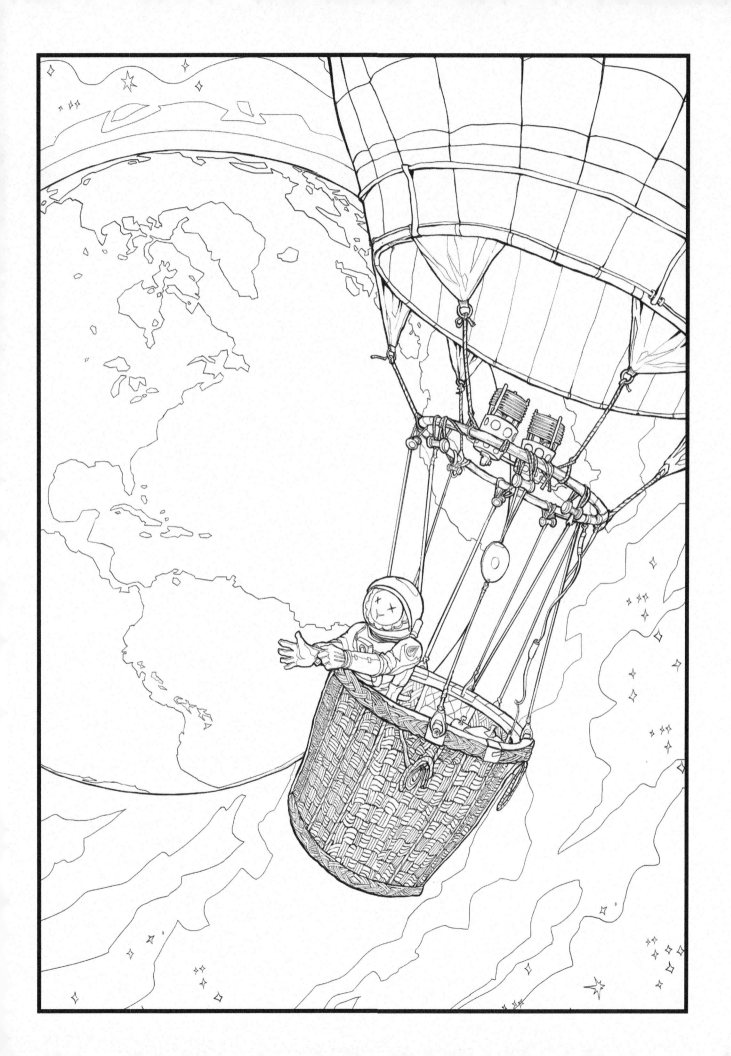

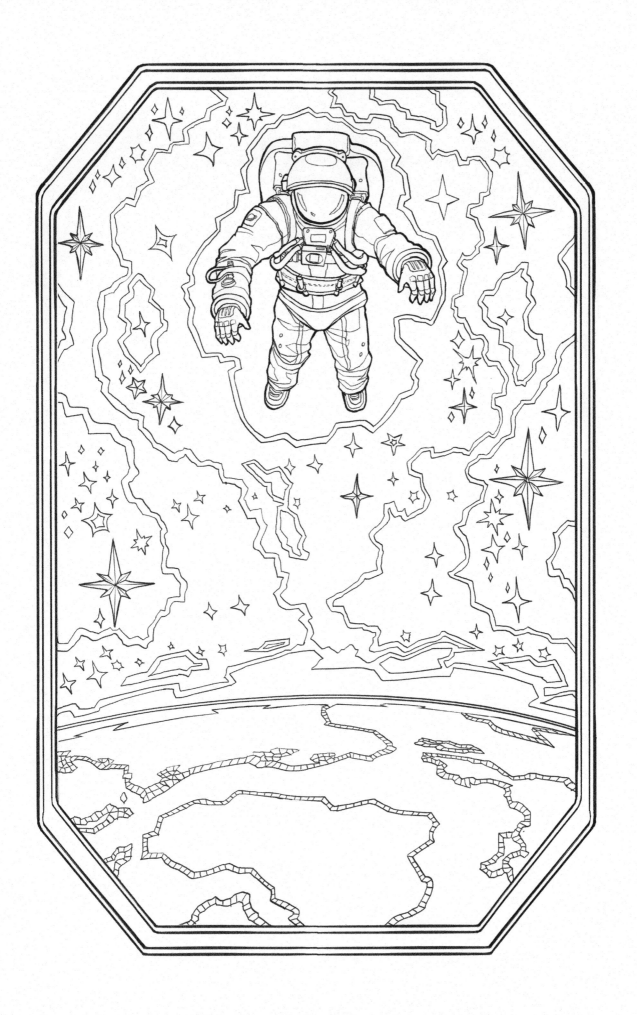

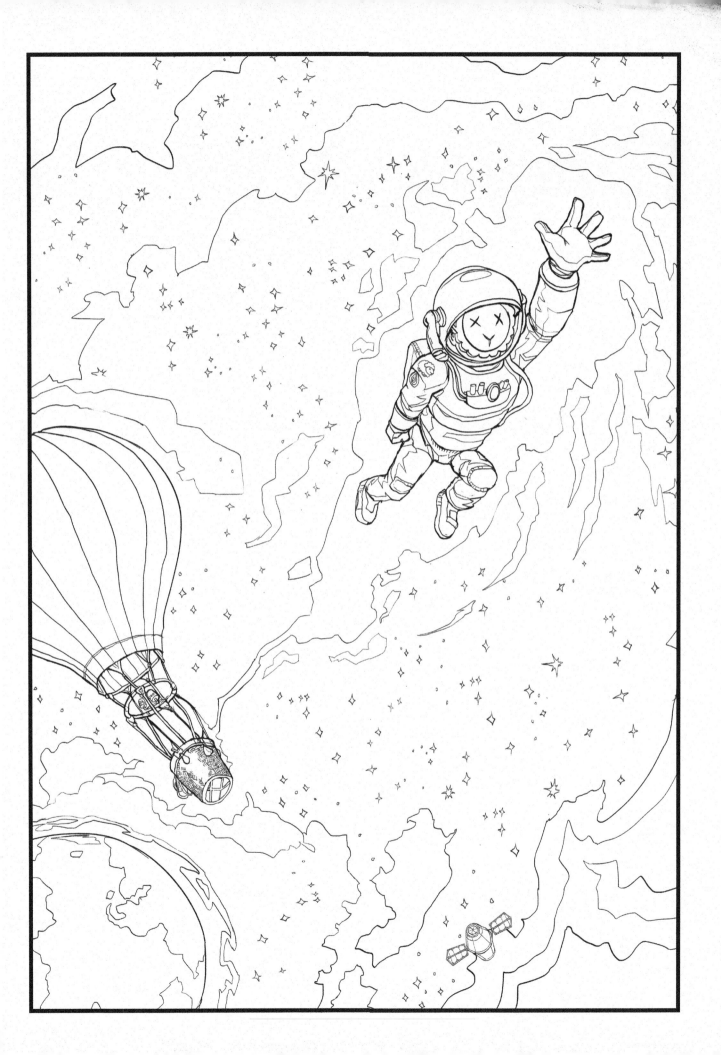

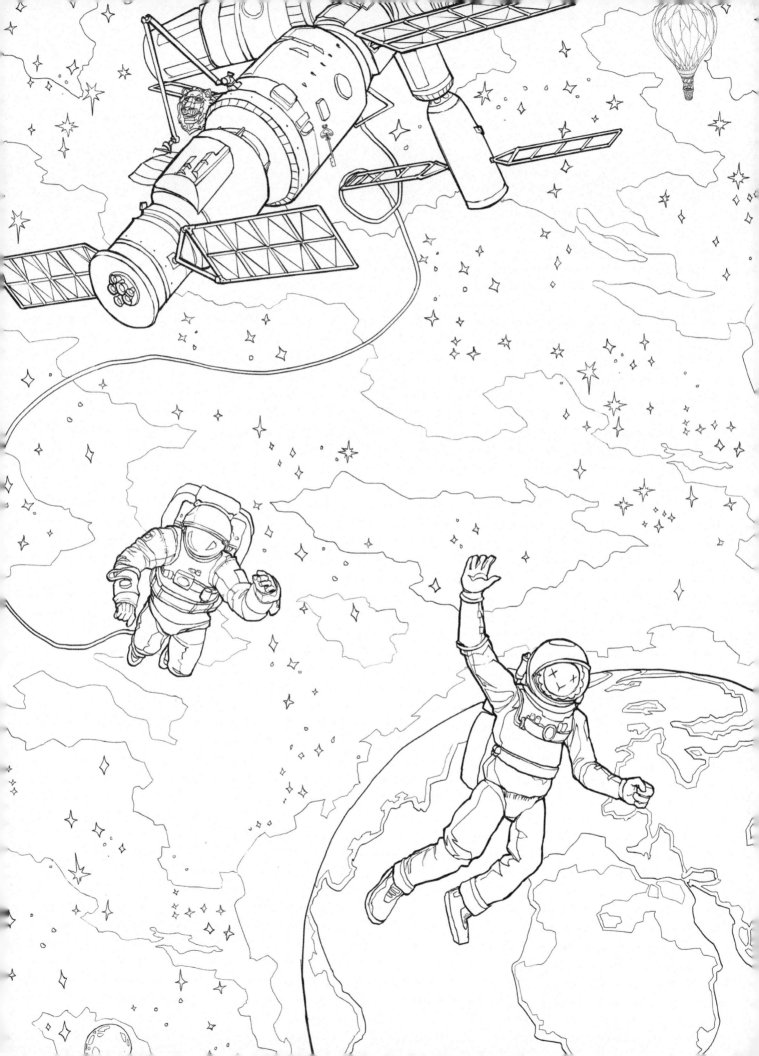

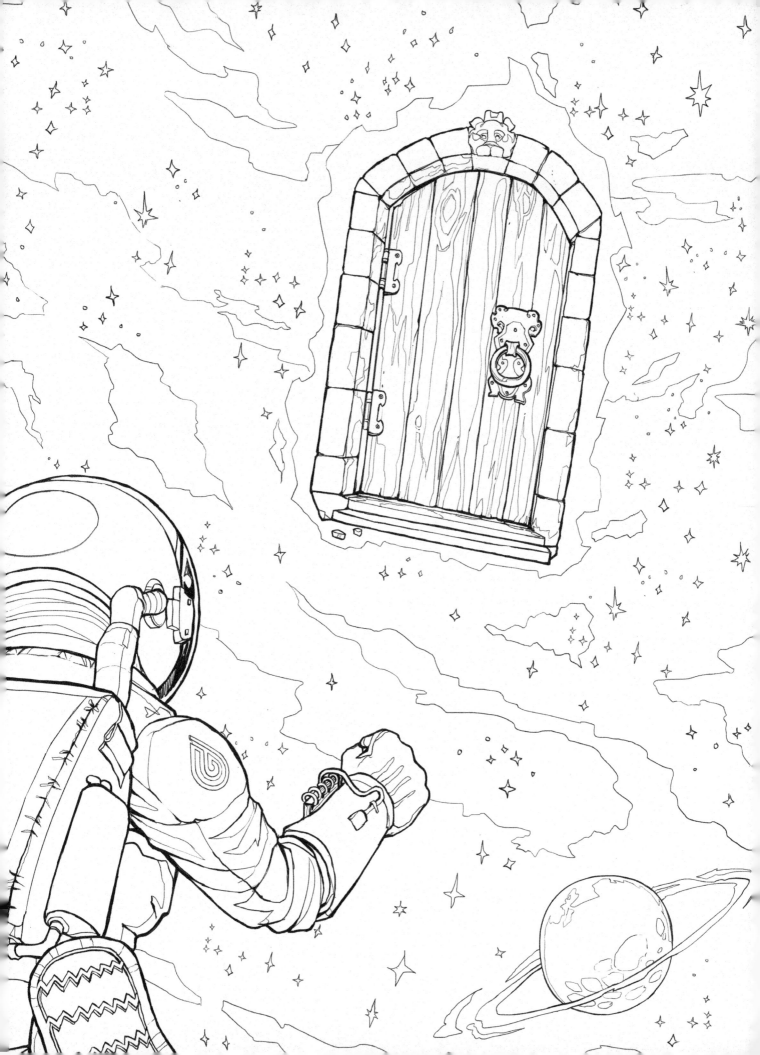

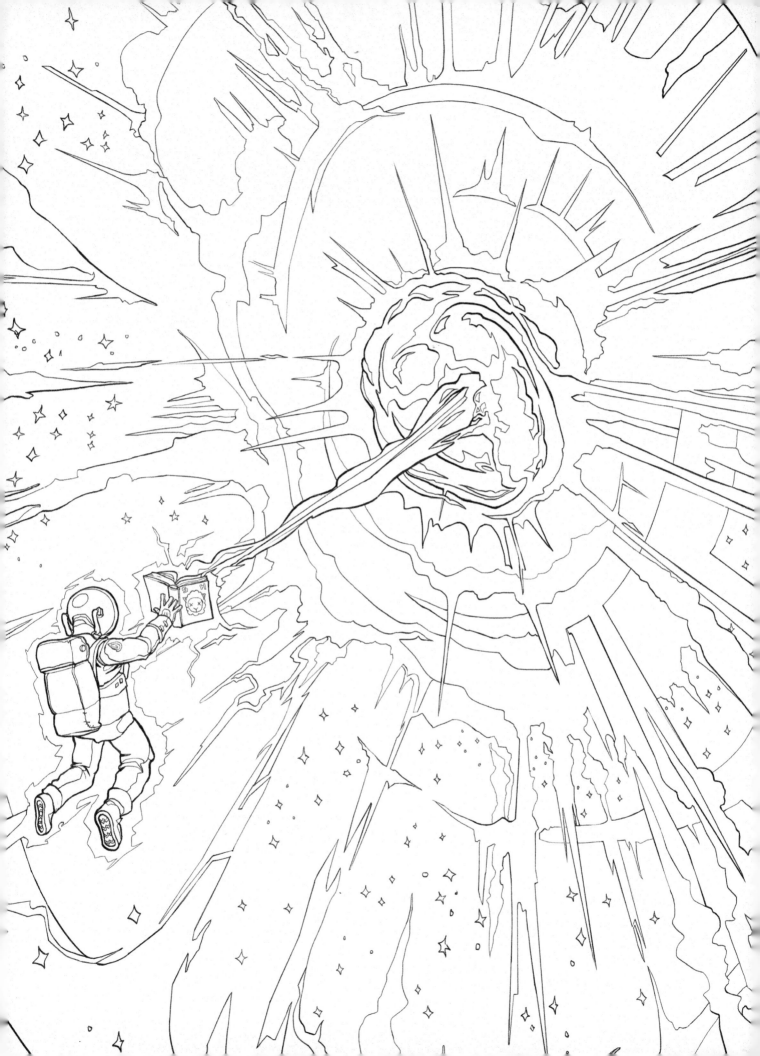

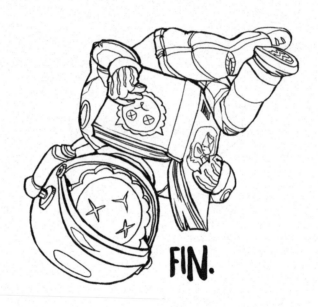

FIN.

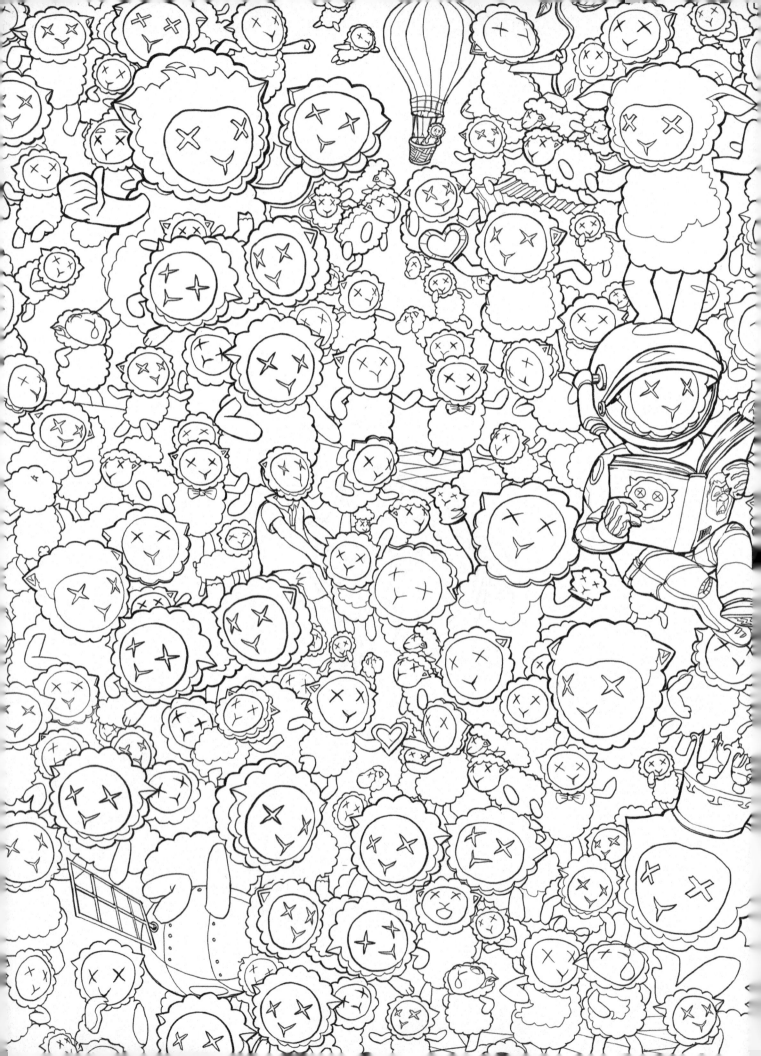

CPSIA information can be obtained
at www.ICGtesting.com
Printed in the USA
BVOW04s0814041217
501906BV00016B/733/P